Molly Dolan Blayney

Happy
Anniversary

Collages by Molly Dolan Blayney

Photographed by Monica Stevenson

Abbeville Press Publishers

New York London Paris

The chief aim of an anniversary is to bring back the scenes or events which to us were occasions of joy or some dear memory which thrills us with the vivid recollection of a time long past—the happy day when two lives flowed into one.

Annie R. White
Polite Society at Home & Abroad, 1891

Editor: Nancy Grubb
Designer: Patricia Fabricant
Production Editor: Abigail Asher
Production Manager: Simone René

Inquiries should be addressed to Abbeville Publishing Group 488 Madison Avenue, New York, N.Y. 10022. Printed and bound in Italy.

First edition

Library of Congress Cataloging-in-Publication Data

Blayney, Molly Dolan.
 Happy anniversary / Molly Dolan Blayney ; collages by Molly Dolan Blayney ; photographed by Monica Stevenson.
 p. cm.
 ISBN 1-55859-656-9
 1. Wedding anniversaries. I. Stevenson, Monica. II. Title.
 GT2800.B53 1994
 394.2—dc20 93-35758
 CIP

Good Luck and Best Wishes

Contents

WE ARE MARRIED –

NOT SO YOU COULD NOTICE IT

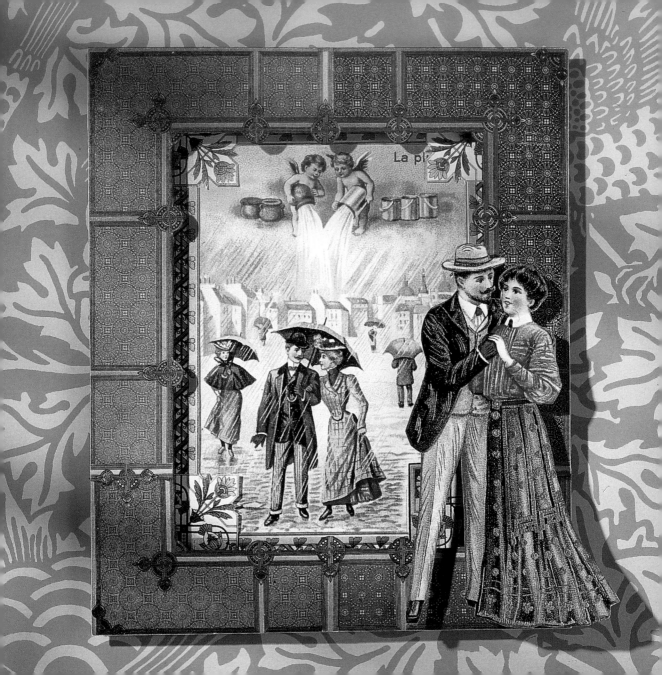

Anniversary
· Themes ·

Anniversaries

First..Paper
Second..Cotton
Third ...Leather
Fifth ..Wooden
Seventh ...Woolen
Tenth ..Tin
Twelfth ..Silk or Linen
Fifteenth..Crystal or Iron
Twentieth...China or Floral
Twenty-fifth ..Silver
Thirtieth...Pearl
Thirty-fifth ...Coral
Fortieth...Ruby
Forty-fifth ...Bronze
Fiftieth...Golden
Sixty-fifth..Crown
Seventy-fifth ..Diamond

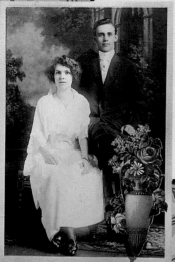

ay your life be as bright
and fair,
As loving hearts
can make it,
Your future be exempt
from care,
No "rainy day" o'ertake it.

· 1 ·
The Paper Anniversary

The first celebration is known as the paper wedding, and is held at the end of the first year of wedded life. Suitable gifts are easily procured, since there are so many beautiful things in paper, as dainty boxes of stationery, books, artificial flowers, fans, glove-holders, bookmarks, lamp-shades, screens, blotters, Japanese panels, sheets of music, knickknacks of *papier mâché,* subscriptions to magazines, and unframed etchings or drawings are a few that suggest themselves.

Annie R. White
Polite Society at Home and Abroad, 1891

The bride of a year may wear her wedding dress, and her bridesmaids should also dress the part. The same bridal party should be gathered together and a bridal table would be a pleasant idea to carry out, with the same guests grouped about it.

W. H. Kistler
Wedding Anniversaries, 1905

· 2 ·

The Cotton Anniversary

This marks the second anniversary. The invitations may be written on white cotton handkerchiefs with indelible ink, the handkerchiefs first being starched to cardboard stiffness and ironed very smooth.

Boxes of spool cotton in assorted sizes, table and bureau mats, crocheted of cotton cord, and, in humbler articles, iron holders and dish-cloths, which in packages of a dozen each, are gifts by no means despised by young housekeepers. Sheets, pillow-cases and towels of cotton are also suitable presents, provided the hostess is not already overstocked.

Serve the menu on pure white china, and have the eatables as white as possible. Vanilla ice cream, heaped in a shell of méringue, colored a pale green, may be served resembling cotton in the pod.

W. H. Kistler
Wedding Anniversaries, 1905

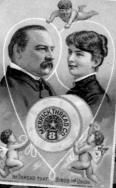

· 3 ·
The Leather Anniversary

Presents appropriate for the third anniversary are innumerable. Leather satchels, trunks, paper folders, desk and slipper cases, perpetual calendars, portfolios, music rolls, dining chairs, dress-suit cases, medicine chests, hunting paraphernalia, traveling bags would seem to afford a wide latitude in articles of the material. Of chamois leather and suede kid, tobacco pouches, blotters, handkerchief cases, desk fittings, book-covers, pen-wipers and glove cases, can be obtained.

Annie R. White
Polite Society at Home and Abroad, 1891

Instead of the traditional bride's-cake in white satin boxes, chocolate cake in dainty boxes of tan leatherette, tied with bronzed or gilt shoestrings, such as are used for lacing fancy shoes can be distributed.

W. H. Kistler
Wedding Anniversaries, 1905

· 5 ·
The Wooden Anniversary

The invitations are sometimes sent on birch bark, or select smooth, thin pine shingles, either red or white, and upon them write the invitations. The shingles can be mailed in envelopes between two pieces of cardboard, or in stiff ones such as photographers use.

W. H. Kistler
Wedding Anniversaries, 1905

The wooden wedding, which was begun in jest with a step-ladder and a rolling-pin several years ago, now threatens to become a very splendid anniversary indeed, since the art of carving in wood is so popular, and so much practised by men and women. Every one is ready for a carved box, picture-frame, screen, sideboard, chair, bureau, dressing-table, crib, or bedstead. Let no one be afraid to offer a bit of wood artistically carved. Everything is in order but wooden nutmegs; they are ruled out.

Mrs. John Sherwood
Manners and Social Usage, 1884

· 10 ·
The Tin Anniversary

Tin weddings, which occur after ten years have passed over two married heads, are signals for a general frolic. A tin screen, tin chandeliers, tin fans, and tin tables have been offered.

Mrs. John Sherwood
Manners and Social Usage, 1884

The host receives with his wife. She again wears her wedding-gown—now old-fashioned enough to be a source of amusement and carries her bouquet in a tin funnel.

Music enlivens the scene, and if there is dancing after the ceremonious part of the entertainment all present should join in a Virginia reel, the bride and groom leading.

Ladies Home Journal, November 1900

Refreshments

· 15 ·
The Crystal Anniversary

An elaborate entertainment may be provided, and handsome glassware is brought by the guests. The articles in order here are countless. Epergnes, berry dishes, bonbon dishes, ice cream sets, lamps, mirrors, goblets, wine glasses, finger bowls, microscopes, vases, bouquet holders, cake dishes, pickle jars, celery boats, cigar jars, all are useful. For the bride's dressing room, vinaigrettes, hand mirrors, ivory brushes with mirror backs, toilet bottles, and bottles of perfume are all included in the "crystal" part of the event.

Manners and Dress, 1900

The table decorations can be made very lovely at slight expense. A large mirror should form the center. Hollowed blocks of ice can hold the salad, and four glass swans, one at each corner, can bear loads of glacé nuts or fruits.

W. H. Kistler
Wedding Anniversaries, 1905

· 14 ·

· 20 ·
The China or Floral Anniversary

A wedding which takes place on the twentieth anniversary has a flavor of solidity, and the presents are in keeping. Sets of china dishes, porcelain ornaments, bisque figures, plaques hand-painted, are very elegant. There is a division of opinion upon the title of this anniversary, some calling it the "floral" wedding. If the latter is preferred, the gifts must be flowers in every form, transforming the house into a bower of beauty.

Annie R. White
Polite Society at Home and Abroad, 1891

This celebration is at the end of twenty years; but is rarely, if ever, celebrated. It is considered very unlucky. The Scotch think one or the other will die within the year the twentieth anniversary is alluded to.

John W. Hanson, Jr.
Etiquette of Today, 1897

· 15 ·

Best Wishes

· 25 ·
The Silver Anniversary

A couple who have lived happily together for twenty-five years are entitled to consideration in these days of loose and irreverent treatment of the marriage tie. This wedding is of importance, and the celebration is in corresponding good taste. The husband and wife are not old—they are still young enough to enjoy heartily the attending ceremonies. Flowers, music and brilliant lighting are necessary accessories. The invitations should be in silver letters on fine white paper.

When the wedding cake is brought on with a ring inclosed, the bride cuts it, and it is claimed that the unmarried lady to whom this slice falls will be a bride within a year.

N.C.
Practical Etiquette, 1894

Sons and daughters take the place of ushers and bridesmaids in receiving

the guests. A silver-gray gown appropriately replaces
the bridal dress, which is seldom available at this time.
It is a very pretty custom to repeat the wedding journey
if it is possible.

Ladies Home Journal, November 1900

The decorations should be white and green with silver, and
bouquets of white flowers should be placed at every cover for
the ladies, with boutonnières for the men. If a guest drinks to the
health of the happy pair, they smile and bow their thanks; and the
husband is at liberty, if he has the desire and gift, to make a little
speech expressive of his happiness and sweetened with grateful
and graceful sentiments concerning his wife.

Emily Holt
Encyclopaedia of Etiquette, 1901

Love seems the swiftest, but is the slowest of all growths.
No man or woman really knows what perfect love is
until they have been married a quarter of a century.

Mark Twain
Notebook, 1897

· 50 ·
The Golden Anniversary

This is an anniversary vouchsafed to but few. Fifty years together!—a half century of varied experiences. Great are the rejoicings, and many the kind wishes of those who partake of this glad occasion. The preparations are even more extensive than for the silver wedding. The form of invitation is the same, save that they are printed in gold letters, and the words thereon are "Golden Wedding." The presents are of that precious metal, and the reader needs no assistance in selecting them.

Annie R. White
Polite Society at Home and Abroad, 1891

Among the loveliest and most suggestive of house decorations for a golden wedding anniversary are groups of palms and gracefully drooping heads of wheat, tied up in small

sheaves. Garlands of laurel and autumnal foliage
are also both charming and pleasantly prophetic of
the afternoon of a happy life.

<div align="right">

Abbey Longstreet
Social Etiquette of New York, 1887

</div>

The aged bride should leave to younger
heads and hands all the preparations for her
guests, and she may with propriety receive
them seated. A wicker chair is easily decorated
like a carriage at a flower-parade. The groom
may be likewise provided for, or he may stand
at his wife's side for a time and then mingle with the
guests. All the children, grand-children and great-grand-children
should be present—a family gathering. The bride wears some
souvenir of her wedding finery. The gown itself may be on exhi-
bition. At the end of the evening all might join in singing "Auld
Lang Syne," as a fitting climax to the occasion.

<div align="right">

Ladies Home Journal, November 1900

</div>

· 75 ·
The Diamond Anniversary

If the wedded pair who have lived together fifty years awaken our admiration, what shall we say of those who journey together for seventy-five years? This is very rare. And when the anniversary is observed, the gifts must be precious stones and valuable. At this, as the gold and silver weddings, the request is generally made that no presents be brought.

Sarah Harper
Anniversary Weddings, 1899

Love is never old and shows more sweet when it has outlived the daily irritations of a long strenuous life such as most mortals are compelled to live. What pleasure then to be present with a group of honest friends to offer congratulations to those whose love time has proved.

Marshall Everett
The Etiquette of Today, 1902

Wedding Anniversary Toasts

May fortune smile on them the rest of their lives.

- To modesty, moderation, and mutuality.
 Modesty in our discourse.
 Moderation in our wishes.
 Mutuality in our affection.
- As we travel through life may we live well
 on the road.
- Be faithful to the end.
- The three blessings of this life.
 Health, wealth, and a good conscience.
- Love, life, and liberty.
 Love pure.
 Life long.
 Liberty boundless.
- To the richest joys out of heaven.
- To love, pure, warm and changeless.
- To the great heart-maker: marriage.
- May these eyes always glow with love.

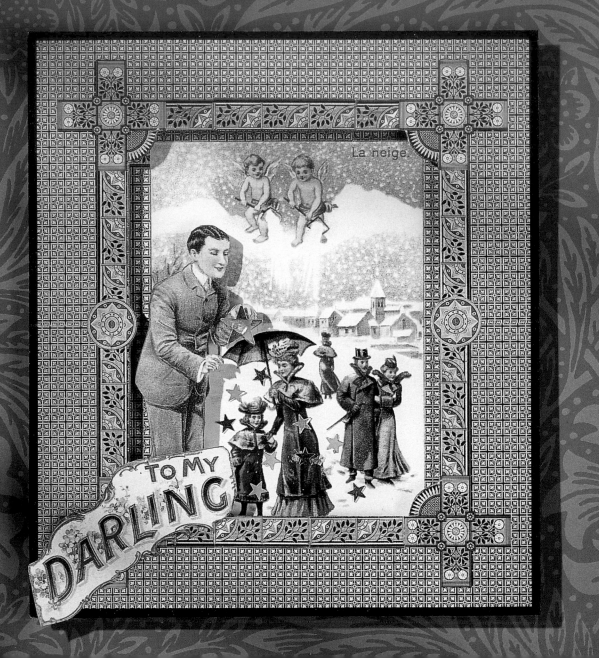

La neige.

TO MY DARLING

How to Be a Model Husband

A Good Lover

Of course, to begin with, every man honestly believes that he has made, is making, or could make a good lover. Wake up now and listen. Your wives have thought about it enough, even if you haven't.

Suppose you occasionally hunted out a new book, and marked it and brought it home to read to her, just to show her that you wanted to do something extra nice for her and to prove that you have a conscience about keeping this precious love at a point where it is still a joy.

A man never seems to be able to get it into his head that in order to obtain the supremest pleasure from an act of thoughtfulness to his wife, he must be wholly unselfish and give it to her the way she wants it. Our way lies through the head to the heart.

And the man who is scrupulously careful, is a real man—a man who knows how to love, even if he has not completely mastered the art of love-making.

Lilian Bell
How Men Fail as Lovers, 1896

· 24 ·

The Model Husband

The model husband does not spend his evenings in barrooms, billiard saloons, and theaters, nor at the club. He finds his highest happiness in the society of his wife. When business or the just demands of society call him away from home, he returns as speedily as possible. When he deems it proper for himself to attend any place of amusement, he thinks it proper for his wife to go also, as she has quite as much need as himself of innocent recreation.

S. R. Wells
Wedlock, 1872

In private, watch your thoughts; in your family, watch your temper; in society, watch your tongue.

Arthur Martine
Handbook of Etiquette, 1866

How a Man Improves

The little oddities of men who marry rather late in life are pruned away speedily after marriage. You may find a man who used to be shabbily dressed, with huge shirt collar frayed at the edges, and a glaring yellow silk pocket-handkerchief, become a pattern of neatness. You have seen a man whose hair and whiskers were ridiculously cut, speedily become like other human beings. Whenever you find a man whom you know little about, oddly dressed or talking ridiculously, or exhibiting any eccentricity of manner, you may be tolerably sure he is not a married man. For the little corners are rounded off, the shoots are pruned away in married men. Wives generally have much more sense than their husbands, especially if the husbands are clever men. The wife's advices are like the wholesome though painful shears snipping off the little growth of self-conceit and folly.

Richard Wells
Manners, Culture and Dress, 1890

• 26 •

A Good Dinner

A good dinner is more to a man than it is to a woman; I do not see why it should be necessary to sneer at a man because he desires and can enjoy a wholesome, well-cooked meal. It is a sign of a healthy body and a sound mind.

Annie S. Swan
Courtship and Marriage, 1894

He may live without books,—what is knowledge but grieving?
He may live without hope,—what is hope but deceiving?
He may live without love,—what is passion but pining?
But where is the man that can live without dining?

Edward Robert Bulwer-Lytton, 1867

Being a husband is a whole-time job.

Arnold Bennett
The Title, 1914

Advice

Books addressed to young married people abound with advice to the *wife* to control her temper, and never to utter wearisome complaints or vexatious words. Would not the advice be as excellent if the husband were advised to conquer *his* fretfulness, and forbear *his* complaints?

Mrs. L. M. Child
The Marriage Offering, 1849

How many anecdotes and stories do you tell your wife to provoke a smile or a laugh? How many roses do you bring home to her? Are you careful of your own appearance in the long evenings when there is no other woman but her to be captivated by your manly charms?

Your answer may be: "My wife knows I love her, and that's enough." She may know it, but if there were many everyday assurances there would be fewer heart-starved wives.

Sylvanus Stall, D.D.
What a Young Husband Ought to Know, 1897

Men as Lovers

The supremest lack of men as lovers is the inability to say, "I am sorry, dear, forgive me" and to keep on saying it until the hurt is clear gone. You gave her the deep wound. Be manly enough to stay by it until it has healed. Men will go to any trouble, any expense, any personal inconvenience to heal it without the simple use of those simple words. A man thinks if a woman begins to smile at him again after a hurt, for which he has not yet apologized, that the worst is over, and that if he keeps away from the dangerous subject he has done his duty. What do you suppose the result would be should you apologize to your wife for something you said last year? If you think she has forgotten, because she never speaks of it, just try it once.

Lilian Bell
How Men Fail as Lovers, 1896

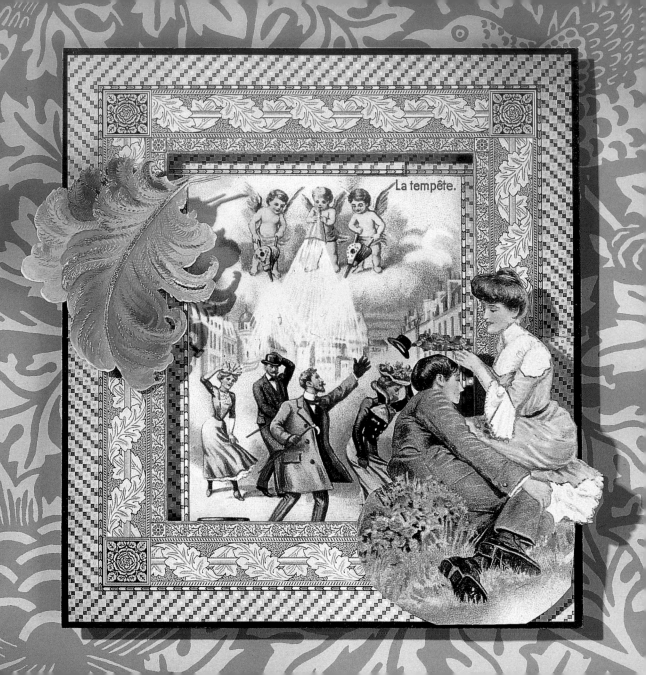

La tempête.

How to
·Be a·
Model
Wife

The Powerful Wife

There isn't a wife in the world who has not taken the exact measure of her husband, weighed him and settled him in her own mind, and knows him as well as if she had ordered him after designs and specifications of her own.

Charles Dudley Warner
"Third Study," 1873

No man knows what the wife of his bosom is until he has gone with her through the fiery trials of this world.

Washington Irving
"The Wife," 1820

A man's wife has more power over him than the state has.

Ralph Waldo Emerson
Journals, 1836

Husbands Who Can be Managed Are Worthless

An editor once asked me to write him an article on "How to Manage a Husband." I answered that I couldn't—first, because I had never tried to manage a husband; second, because I didn't believe in managing husbands, and last, because a husband who could be managed would be a poor kind of creature whom it would be scarcely worth while to waste thought upon.

Helen Watterson Moody
Ladies Home Journal, March 1899

His wife not only edited his works but edited him.

Van Wyck Brooks
The Ordeal of Mark Twain, 1920

Don't worry, I'll hold on to you

"Talking Shop" at Home

The English wife frowns upon any discussion of her husband's business in her home. She holds this as a strict rule with her husband's friends who come to her house, and she even carries it to such an extent that she rarely speaks of his business even with him. The American wife differs from her English sister in this respect. She allows her husband's friends to "talk shop" when they come to her home, and, as a rule, she is his most constant and confidential adviser in matters of business. Englishmen visiting America see this. One of them recently said to me: "I believe one reason why you have in America a larger number of successful business men than we have is because the American husband makes his wife a sort of silent partner in his business. He consults her, and her counsel weighs with him. On several occasions

I have been really amazed to see how thoroughly conversant your American women were with their husbands' business affairs. It gave me a feeling that these women were quiet but very potent factors in their husbands' success."

Ladies Home Journal, October 1896

To Be a Model Wife

My advice to the young wife is, don't nag. Be cheerful. Swallow the pill at any cost, but above all, don't nag! A man will stand almost anything but nagging. Don't save up a long string of miseries, small and big, to pour on to him the moment he puts his head in at the door.

Annie S. Swan
Courtship and Marriage, 1844

Woman in the Year 2000

Obviously the most important single respect in which her position would be altered would be her attitude toward marriage. She would no longer be obliged, as most women now are, to look forward to marriage as offering *her only means of support.* The only possible motive which would then impel her to give herself to a man would be that she loved him. May and December might still mate, Beauty might still wed the Beast, but the sourest cynic would no longer be able to attribute an unworthy motive to the bride. Not only would she be under no necessity of marrying at all, she could have no motive, save love or admiration, for marrying.

Edward Bellamy
Ladies Home Journal, February 1891

Avoid the Weak Points

Married people should study each other's weak points as skaters look out for the weak points of the ice, in order to avoid them. Ladies who marry for love should remember that the union of angels with woman has been forbidden since the flood. The wife is the sun of the social system. Unless she attracts, there is nothing to keep heavy bodies like husbands from flying into space.

Godey's Lady's Book, 1853

How to Make an Ideal Home

A Sanctuary

The ideal relationship betwixt husband and wife has always appeared to me to be comradeship, a standing shoulder to shoulder, upholding each other through thick and thin, and above all keeping their inner sanctuary sacred from the world. The privacy of domestic life cannot be too sacredly guarded; the home ought to be—to tired men and women—a veritable sanctuary where they can be at peace.

Annie S. Swan
Courtship and Marriage, 1894

Make Home Happy

It is a duty devolving upon every member of a family to contribute something toward improving their house. If the house is old and uncomfortable, let each exert himself

to render it better and more pleasant. If it is good and pleasant, let each strive still further to adorn it. Let flowering shrubs and trees be planted, and vines and woodbines be trailed around the windows and doors; add interesting volumes to the family library; take a good paper; purchase little articles of furniture to replace those which are fast wearing out; wait upon and anticipate the wants of each; and ever have a pleasant smile for all.

There are few homes which might not be made more beautiful and attractive. Let all study to make their residence so pleasant that the hearts of the absent ones shall go back to it as the dove did to the ark of Noah.

S. R. Wells
Wedlock, 1872

Peace and Comfort

Man is strong, but his heart is not adamant. He needs a tranquil home, and especially if he is an intelligent man with a whole head, he needs its moral force in the conflict of life. To recover his composure home must be a place of peace and comfort. There his soul renews its strength and goes forth with renewed vigor to encounter the labor and troubles of life.

T. Payson
A Marriage Keepsake, 1874

Be Neat

It is hard to imagine a happy home that is neither neat nor clean. Neatness and cleanliness in the home are sure to lead to neatness and cleanliness in the persons of the home.

No home is attractive in which the wife is careless in her personal appearance. The husband, too, should be careful of his personal appearance. Undoubtedly he was so before his marriage.

Frank A. De Puy
The New Century Home Book, 1900

Beautify

Adorn your home with your own hands. Beautify the lawn, the shrubbery, and all external surroundings. It matters not how great your wealth, or how small your purse, every consideration, effort and sacrifice you make in these directions will add to your own health and happiness and endear you to your wife.

Sylvanus Stall, D.D.
What a Young Husband Ought to Know, 1897

In-Laws

Should it be an absolute necessity to live with a mother-in-law or a father-in-law, or to have either live in the new home during the first twelvemonth, patience, gentleness, and grace will be imperative in everybody.

Margaret E. Sangster
Good Manners for All Occasions, 1904

Plants and Flowers in the Home

No room in the house should be without its flower or growing plant. Do not be content with the furnishing of your home until plants and flowers are included. They do more than any other one thing to brighten the home and its surroundings. And there is not a home in the land so poor that it cannot have a flower or plant.

Frank A. De Puy
The New Century Home Book, 1900

At the Table

The breakfast table is not a bulletin board for the curing of horrible dreams and depressing symptoms, but the place where a bright key-note for the day is struck. The supper-table is not a battle-field, but a pleasing panorama of what has occurred during the day in the outer world.

Helen Jay
Ladies Home Journal, May 1886

A Residence of the Heart

A house is a mere skeleton of bricks, lath, plaster and wood; a home is a residence, not merely of the body, but of the heart. It is a place for children to live, and learn, and play in— for husband and wife to toil smilingly together to make life a blessing.

Richard A. Wells
Manners, Culture and Dress, 1890

Shakespeare's Birthplace in Stratford-on-Avon

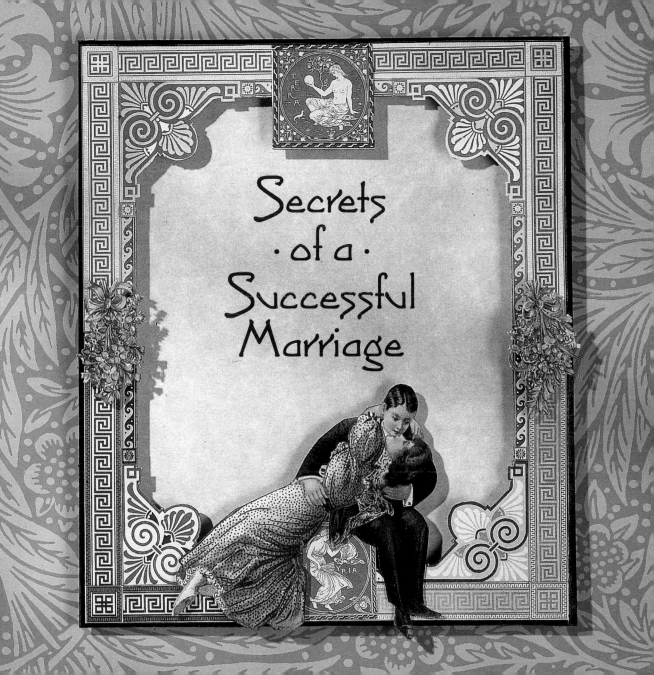

Secrets
·of a·
Successful
Marriage

Happy Husband, Happy Wife!

I know of hundreds of very happy marriages where the husband and wife are all the world to each other, where the husband tells his annoyances, and the wife listens attentively, where the wife tells the troubles and is sympathized with, and where after that they throw care to the winds, and say, "Who cares? We have each other." Happy husband, happy wife! Nothing is serious to them but their love. If business troubles come, they console themselves with the thought that so long as they have each other it doesn't so much matter what else happens. They know the true oneness of a marriage, the love that makes them prize an evening passed together in each other's society as far more delightful than all the fine dinner parties that ever were given.

Ladies Home Journal, September 1889

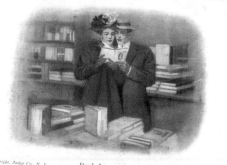

Copyright, Judge Co., N. Y. Book Lovers.

A HIGH OLD TIME

Copyright, 1905, by U. S. S. P. C. Co., No. 392

Little Compromises

This life of ours is a constant series of compromises, of concessions, of surrenders of what we hold dearest, and acceptances of what seems second best.

There is one place where the spirit of compromise has only its beautiful side—that is, the home. In the home where we can turn a key and lock our world in and the smaller world out, compromise reaches its highest dignity. It is love manifesting itself in kindness, thoughtfulness, tenderness, forbearance and self-surrender. Love makes such compromise an instinct of the soul. It is as inseparable from real love as perfume is from the rose that exhales it. Compromise, in its true sense, is settling differences by mutual concessions. To be real it must ever be mutual. Concession in the home is the fine diplomacy of the heart.

William George Jordan
Little Problems of Married Life, 1910

WHEN LOVE IS ON THE WEIGH

A Better Way to Say It

It is hard to get a letter telling about the weather and how busy he is, when the same amount of space saying that he got to thinking about you yesterday, when he saw a girl on the street who looked like you, only she didn't carry herself so well as you do, and that he loves you, good-by—would have fairly made your heart turn over with joy, and made you kiss the hurried lines and thrust the letter in your belt, where you could crackle it now and then just to make sure it was there.

Sarah F. Littlebrown
A Happy Marriage, 1890

Save Some Love for Tomorrow

Lavish not all your love on to-day; for remember that marriage has its to-morrow likewise, and its day after to-morrow, too. Spare, as one may say, fuel for the winter.

The Marriage Offering, 1844

JUST TO SHOW THAT I THINK OF YOU

To my Wife.

Marital Resemblance

That husbands and wives who have lived long ago and in true love relations with each other often look alike has often been remarked, though the spiritual law which governs this gradual but certain approximation of kindred beings to each other has seldom been explained.

R. F. Dudley
An Offering, 1882

The silken texture of the marriage tie bears a daily strain of wrong and insult to which no other human relation can be subjected without lesion.

William Dean Howells
The Rise of Silas Lapham, 1885

Matrimonial Deportment

Let the rebuke be preceded by a kiss.

Do not require a request to be repeated.

Never should both be angry at the same time.

Never neglect the other, for all the world besides.

Let each strive to always accommodate the other.

Let the angry word be answered only with a kiss.

Bestow your warmest sympathies in each other's trials.

Make your criticism in the most loving manner possible.

Never make a remark calculated to bring ridicule upon the other.

Never deceive; confidence, once lost, can never be wholly
 regained.

Always use the most gentle and loving words when addressing
each other.

Let each study what pleasure can be bestowed upon the other
during the day.

Always leave home with a tender good-bye and loving words.
They may be the last.

Consult and advise together in all that comes within the experi-
ence and sphere of each individually.

Never reproach the other for an error which was done with a
good motive and with the best judgment at the time.

Margaret E. Sangster
Good Manners for All Occasions, 1904

TULIPS

The Secret of Conjugal Happiness

The great secret of conjugal happiness is in the cultivation of a proper temper. It is not so much in the great and trying scenes of life that the strength of virtue is tested; it is in the events that are constantly occurring. Great deeds rarely occur. The happiness of life depends little on them, but mainly on the little acts of kindness in life. We need them everywhere, we need them always. And eminently in the marriage relation there is need of gentleness and love returning each morning, beaming in the eye and dwelling in the heart through the livelong day.

Dr. Albert Barnes
The Marriage Vow, 1877

It takes patience to appreciate domestic bliss; volatile spirits prefer unhappiness.

George Santayana
The Life of Reason, 1906

Recipe for Making Every Day Happy

When you rise in the morning, form a resolution to make the day a happy one to a fellow-creature. It is easily done; a left-off garment to the man who needs it, a kind word to the sorrowful, an encouraging expression to the striving; trifles in themselves. If you are young, depend upon it—it will tell when you are old; and if you are old, rest assured—it will send you gently and happily down the stream of human time to eternity.

Sidney Smith
The (Old) Farmer's Almanack, 1874

Marriage is three parts love and seven parts forgiveness of sins.

Langdon Mitchell
The New York Idea, 1907

AN IVY MOTTO

"WE CLING"

Like unto
The IVY leaves
let us be
we two
If you'll only cling
to me
I will cling to you.

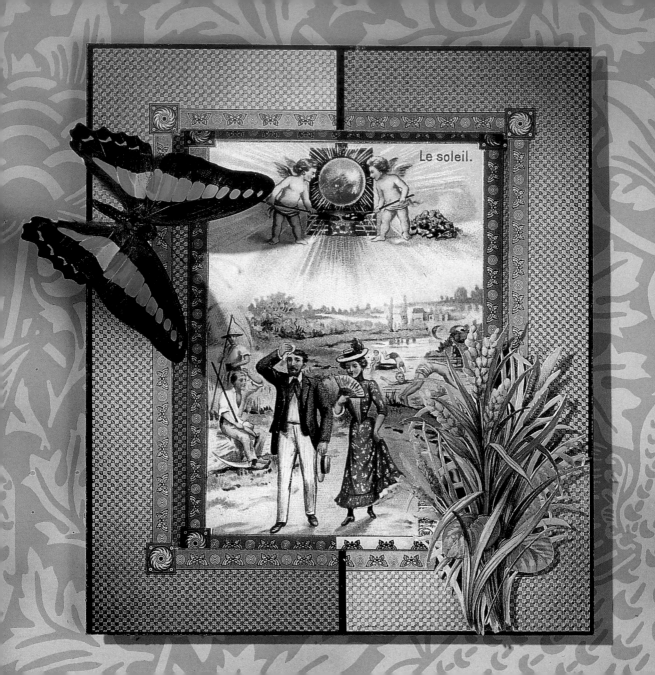

Le soleil.

LOVE

Benefits
· of ·
Wedlock

Why Married People Live Longest

Dr. Hall, in one of his excellent "Health Tracts," gives the following as the reasons why marriage is favorable to health:

1st. By its making home inviting.

2d. By the softening influences which it has upon the character and the affections.

3d. By the cultivation of all the better feelings of our nature, and in that proportion saving from vice and crime.

4th. There can be no healthful development of the physical functions of our nature without marriage; it is necessary to the perfect man, for Divinity has announced that it was "not good for a man to be alone."

5th. Marriage gives the enjoyment in witnessing happiness, and the daily interchange of thought: these are the considerations which lighten the burdens of life, thus strewing flowers and casting sunshine all along its pathway.

Richard A. Wells
Manners, Culture and Dress, 1890

Advantages of Union

Intellectual beings of different sexes were intended to go through the world together: thus united, not only in hand and heart, but in principles, in intellect, in views, and in dispositions; each pursuing one common and noble end—their own improvement.

Lady Rachel Russell
The Marriage Offering, 1849

Bachelors Beware

Dr. Stark, Registrar-General of Scotland, finds, according to his recently published memoir, that, in that country, the death-rate of the bachelors between the ages of twenty and twenty-five years is double that of the married men. As the age increases the difference between the death-rates of the married and unmarried decreases; but it still shows a marked advantage in favor of the married men at each quinquennial period of life.

A. M. Whitfield
The Record, January 1898

Marriage is popular because it combines the maximum of temptation with the maximum of opportunity.

George Bernard Shaw
Man and Superman, 1903

Growing Old Together

Men and women make their own beauty or their own ugliness. Beauty is not the monopoly of blooming young men and white-and-pink maids. There is a slow-growing beauty which only comes to perfection in old age. Grace belongs to no period of life, and goodness improves the longer it exists. I have seen sweeter smiles on a lip of seventy than I ever saw on a lip of seventeen. Husband and wife who have fought the world side by side, who have made common stock of joy or sorrow, and aged together, are not unfrequently found curiously alike in personal appearance and in pitch and tone of voice—just as twin pebbles on the beach, exposed to the same tidal influences, are each other's *alter ego*. He has gained a feminine something which brings *his* manhood into full relief. She has gained a masculine something which acts as a foil to her womanhood.

D. Richardson
Principles of Happy Home, 1889

Eden Is Still Possible

We are constantly being told that we live in a hard, prosaic age, that romance has no place in our century, and that the rush and the fever of life have left little inclination for the old-time grace and leisure with which our grandfathers and grandmothers loved, wooed, and wed.

This study of human nature is my business, and it appears to me that the world is very much as it was—that Eden is still possible to those who are fit for it; and it is beyond question that love and marriage are words to conjure with in the garden of youth, and that a love-story has yet the power to charm even sober men and women of middle age, for whom romance is mistakenly supposed to be over.

Annie S. Swan
Courtship and Marriage, 1894

The True Spirit of Married Life

They who are united in this closest bond of friendship will offer to each other the sympathy and counsel suitable to each. In sickness, each will be the other's care; in perplexity, each the other's resource and guide; in dejection, each the other's stay. Rich, they will be happy in each other's good fortune. Poor, they will be animated by the view of each other's fortitude. Joys will all be doubled, and sorrows lessened, by the true spirit of married life.

John G. Palfrey
The Marriage Offering, 1849

Acknowledgments

This book celebrates marriage, a happy union of shared goals. Such is illustrated on each and every page of this book, where my ephemera marry the noble wallpapers of Bradbury & Bradbury in Benicia, California. I am particularly grateful to Tom Newcomb, to Bruce Bradbury, Paul Duchscherer, and Jan McHargue for their inspiration and good will. It was indeed a happy marriage.

Loving gratitude goes to my nephew, Mark Yancey, who generously eased the writing process with a gift of a computer. Its arrival offered an excursion into the twentieth century.

Many thanks to Robert E. Abrams, Nancy Grubb, Patricia Fabricant, Monika Keano, Simone René, Ada Rodriguez, Rozelle Shaw, Lori Horak, Jim King, and all others at Abbeville Press who have worked toward making this book a success.

To Carolyn Barr, Ben Burns, Gene Guthrie, Deborah Harding, Maggie and Don Higgins, Zena Intze-Kostas, Eleanor Lambertsen, Gene Morin, Mary Lou O'Callaghan, Regina Ryan, Tracy Smith, Monica Stevenson, Allan Temko, and Carmen Wyllie—thank you one and all.